Puerto Rico through my lens

-I-

Images of San Germán

ALBERTO R. ESTRADA

Copyright © 2016 Alberto R. Estrada

All rights reserved.

ISBN: 1533305188

ISBN-13: 978-1533305183

CONTENT

CONTENT	1
ACKNOWLEDGMENTS	3
INTRODUCTION	4
DAWNS IN GUAYNABO	5
MORALES –MARCO RESIDENCE	6
DOMINGUEZ PHARMACY	7
OLD CITY HALL	8
MAIN SQUARE	9
MOON STREET	10
GELPÍ-DELGADO PALACE	11
OLD WOODEN HOUSE	12
SUN THEATER	13
PORTA COELI CHAPEL	14
WOODEN CROSS	15
SANTO DOMINGO PARK	16
LAS LOMAS RESTAURANT	17
DAWN IN MOON STREET	18
SANTO DOMINGO PARK	19
BELL TOWER	20
COSS OF THE MOON	21
ORCHIDS ON THE CORNICE	22
A RUIZ-BELVIS STREET CORNER	23

BRICK STEPS TO THE CHAPEL	24
RAMA STREET	25
PIGEON ON BRICKLAYING WALK	26
ABOUT THE AUTHOR	27

ACKNOWLEDGMENTS

I want to thank everyone who throughout life have stimulated my dedication to photography.

INTRODUCTION

Since I moved to Puerto Rico in 1997, almost whenever I had the chance to travel through the different ends of the wonderful islands forming the easternmost islands of the Greater Antilles, it accompanied me a camera of 35 mm or digital camera. So was becoming a habit to see the landscape and the environment to my around through the lens of my camera, which were leaving testimony of the charms of the islands of Puerto Rico.

On this occasion I am pleased to share with the public some pictures of San Germán. A municipality in the southwest of the main island of Puerto Rico, established as a definite human settlement in 1573. It has an area of just over 141 square kilometers (54 square miles).

DAWNS IN GUAYNABO

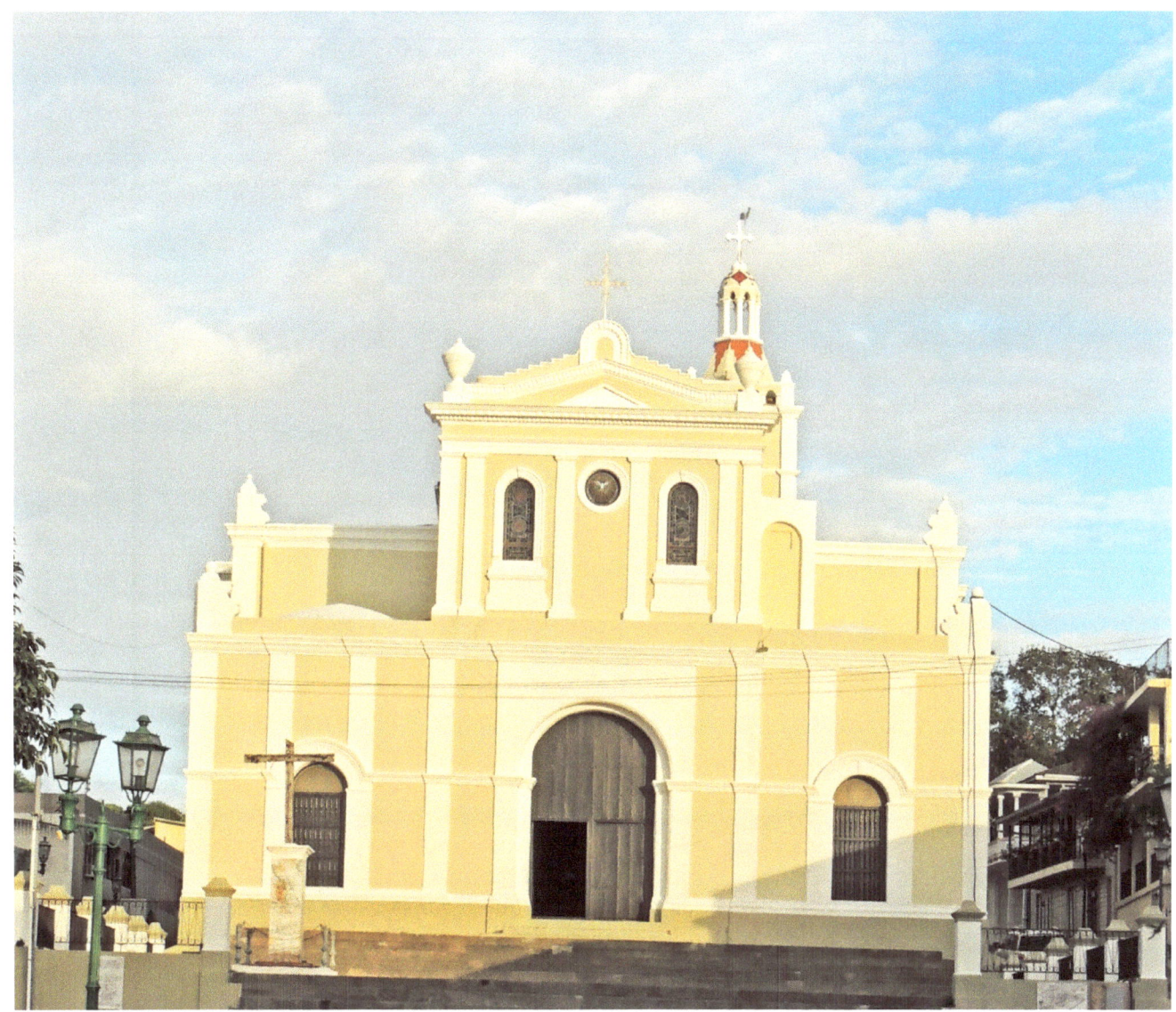

Catholic Parish Church of St. Germanus of Auxerre (Iglesia católica parroquial de San Germán de Auxerre)

MORALES – MARCO RESIDENCE

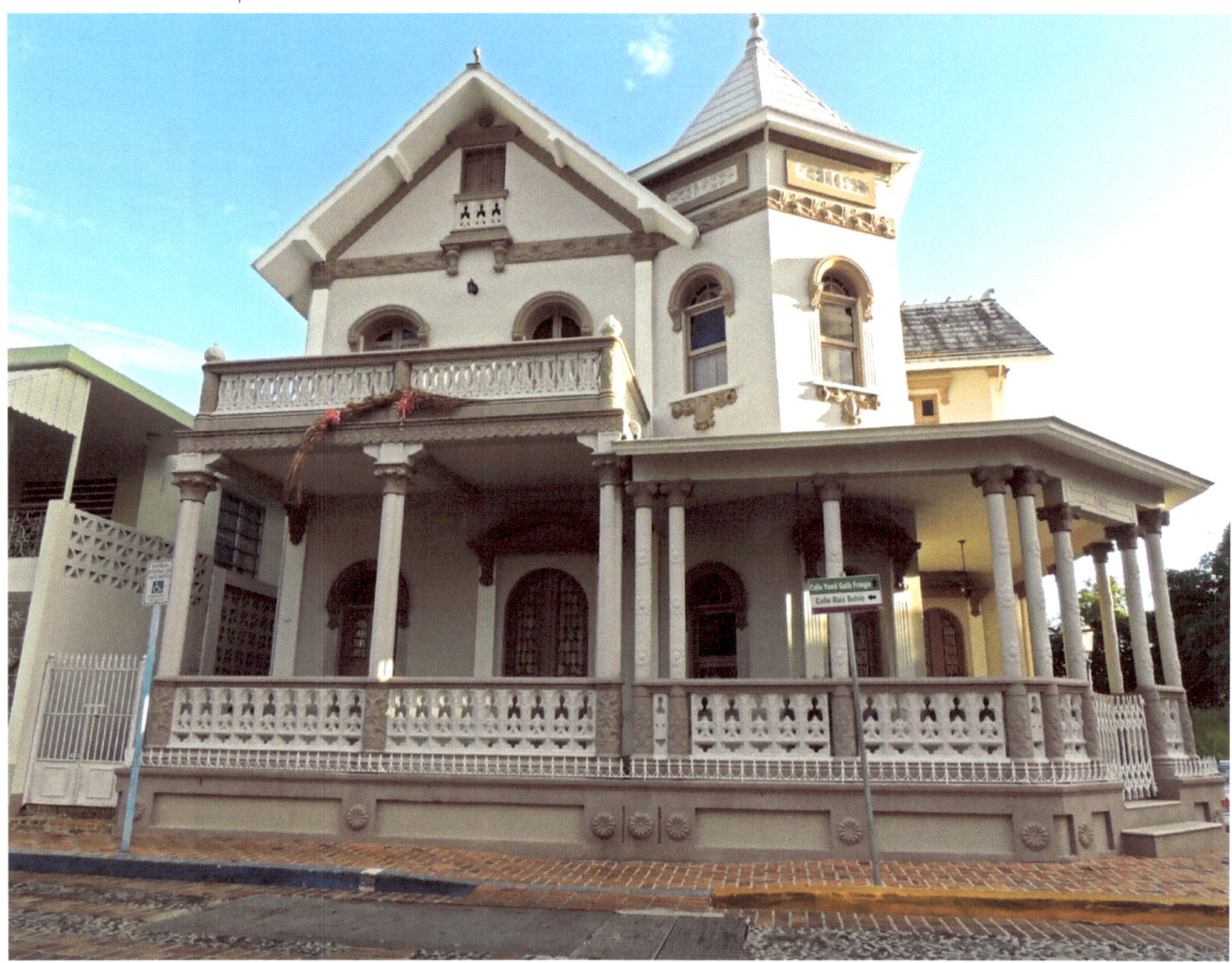

Morales-Marco residence. Beautiful residence style queen. It is a good example of the English influence in Puerto Rican architecture early twentieth century. Built in 1915. Located at the end of the Ruíz Belvis Street (Residencia Morales Marco. Hermosa residencia estilo reina. Es buen ejemplo de la influencia inglesa en la arquitectura puertorriqueña de principios del siglo XX. Construída en 1915. Situada al final de la calle Ruíz Belvi

DOMÍNGUEZ PHARMACY

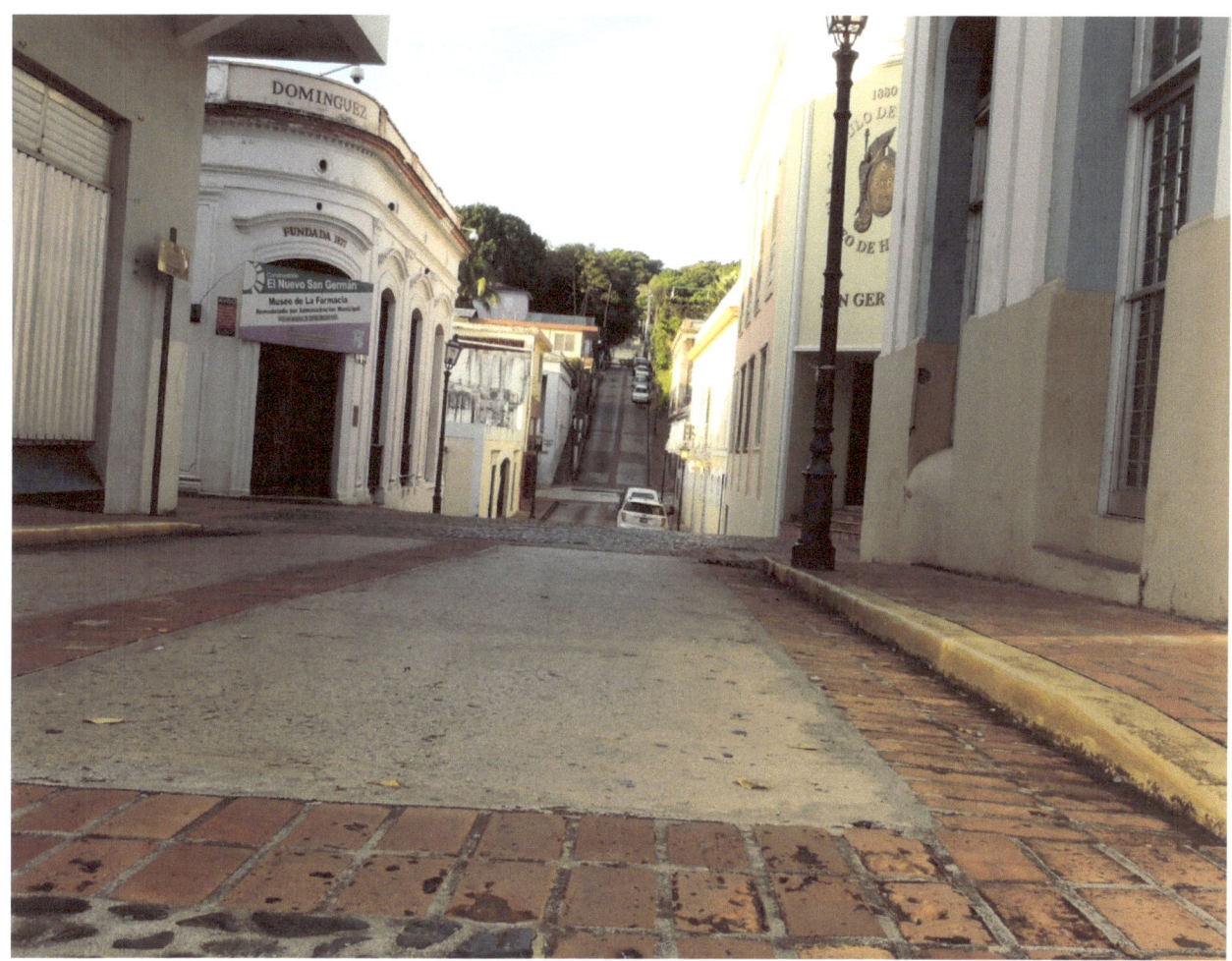

Cross's Street, where is located the building Dominguez Pharmacy, founded in 1877 and operated by the Dominguez family until 1960 (Calle de la Cruz, donde está ubicado el edificio de la Farmacia Domínguez, fundada en 1877 y operada por la familia Domínguez hasta 1960)

OLD CITY HALL

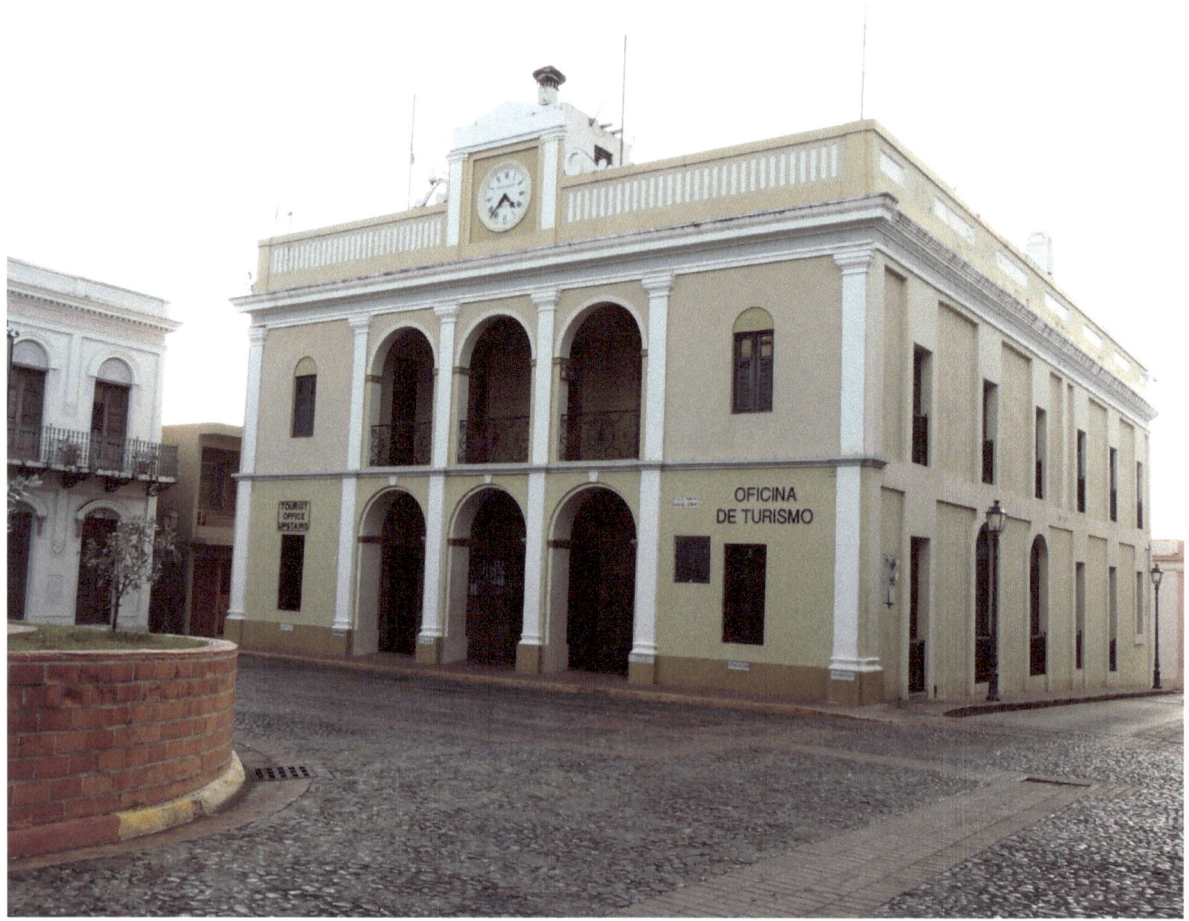

Old City Hall built in San Germán between 1839-1844. It housed the city government until 1989. Today the building is home to the Tourist Office and other local agencies (Antigua casa ayuntamiento, construida en San Germán entre 1839-1844. Albergó al gobierno municipal hasta 1989. Hoy el edificio es sede de la Oficina de Turismo y otras dependencias locales)

MAIN SQUARE

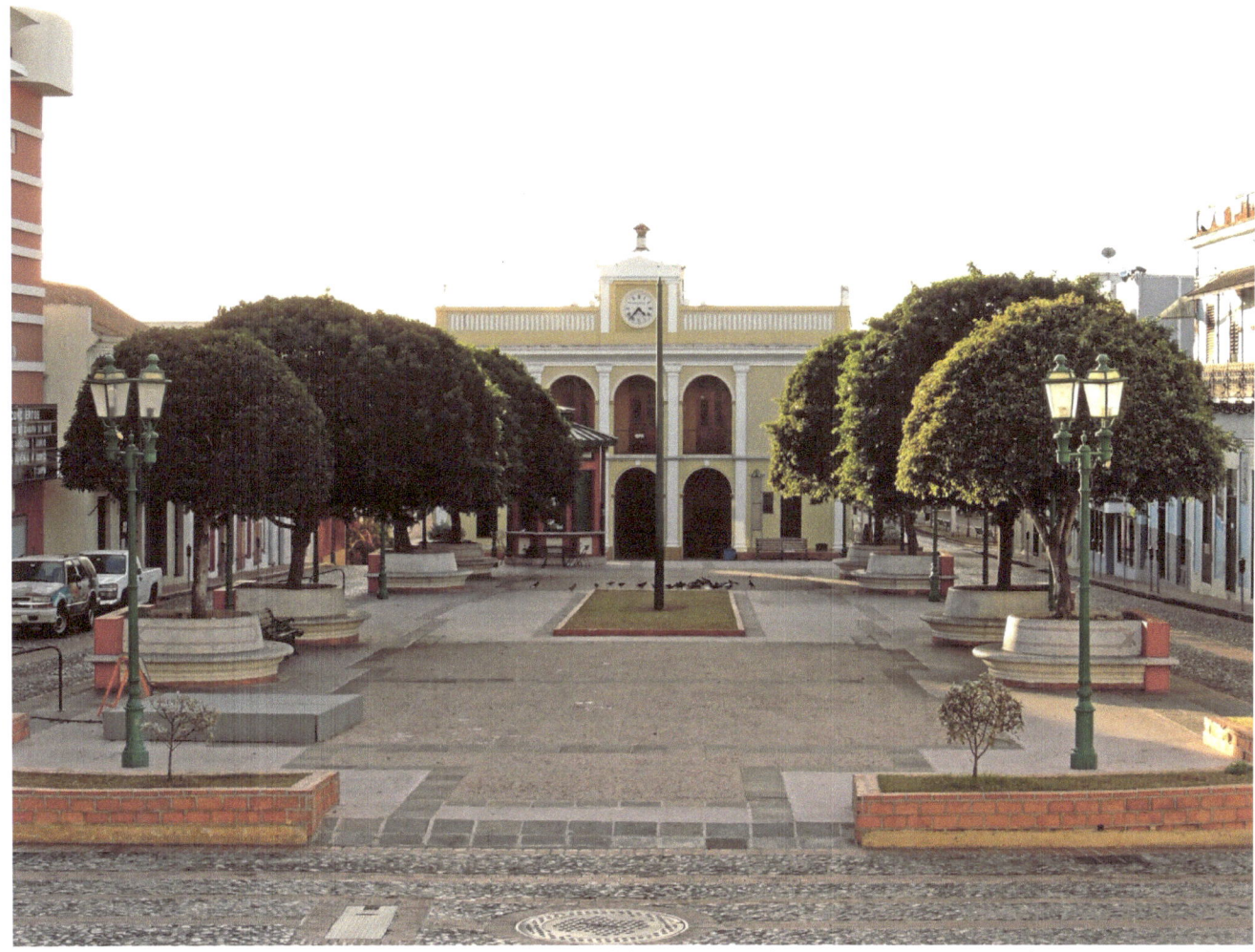

Plaza Francisco Mariano Quiñones, located between the St. Germanus of Auxerre and the former City Hall. It was Market Square until the early twentieth century (Plaza Francisco Mariano Quiñones, localizada entre la Iglesia San Germán de Auxerre y la Antigua Casa Alcaldía. Fue Plaza del Mercado hasta principios del Siglo XX)

MOON STREET

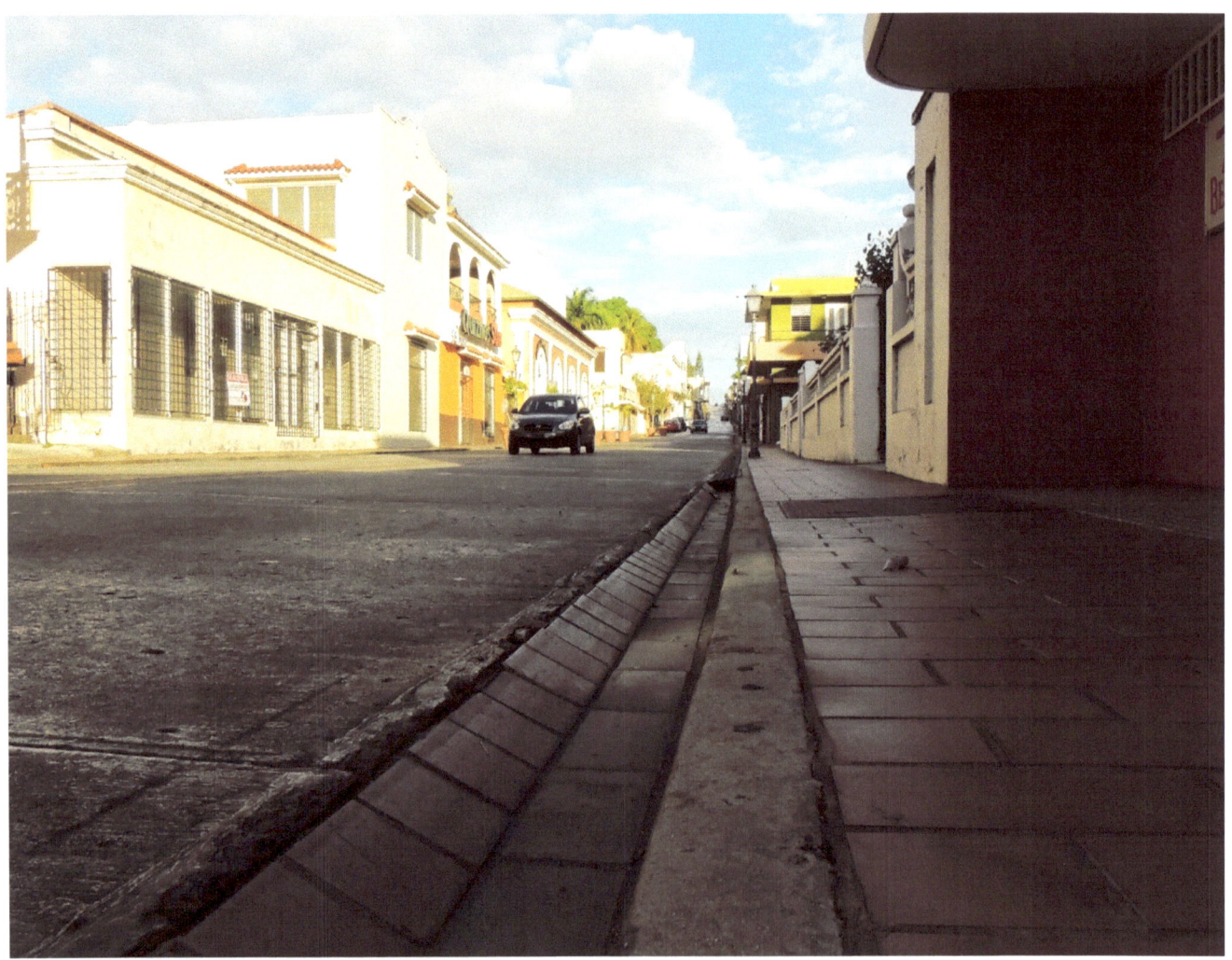

Moon Street, one of the main streets of the town of San Germán (La calle Luna, una de las calles más céntricas de la villa de San Germán)

GELPÍ-DELGADO PALACE

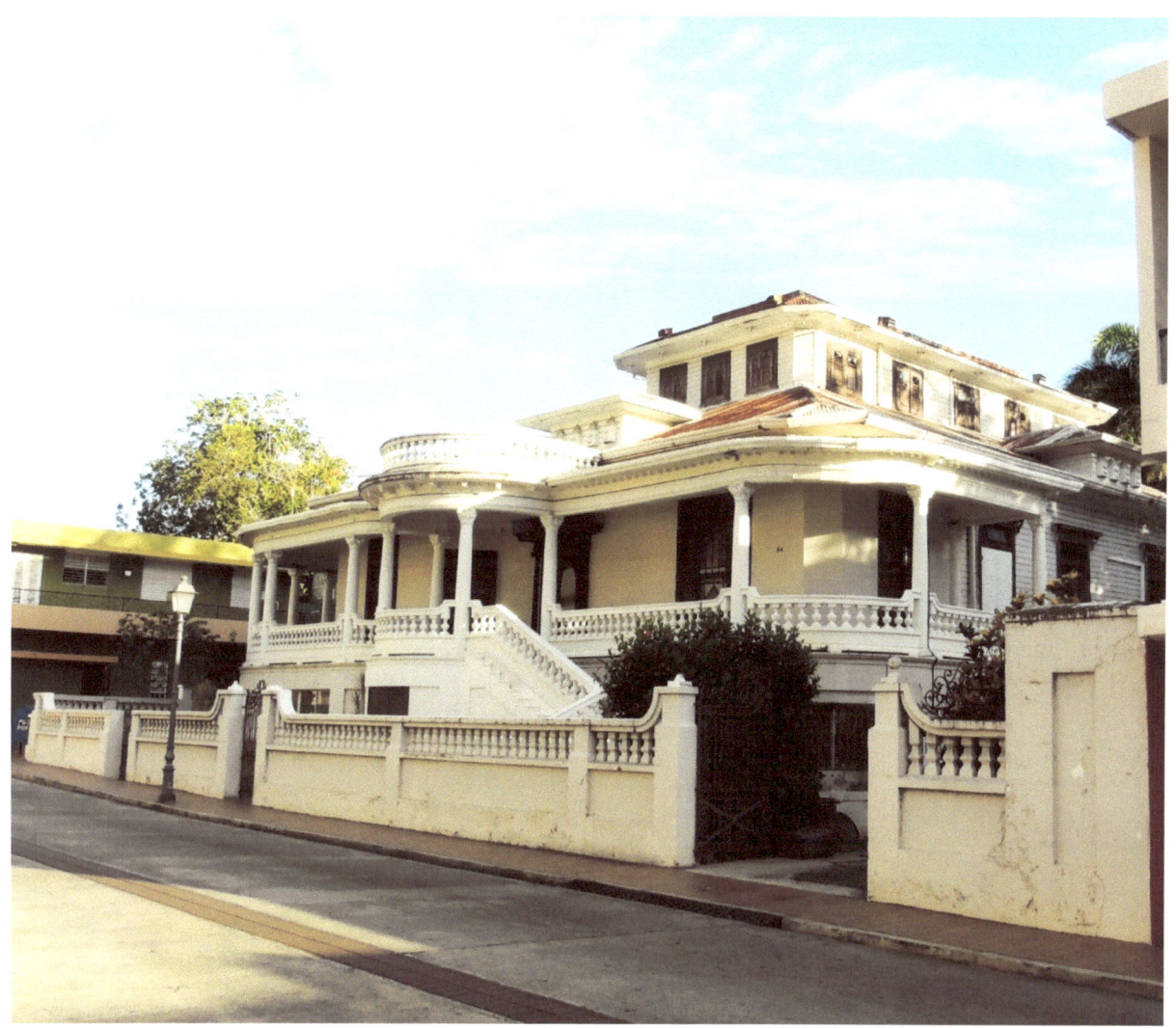

Mansion of the Gelpí-Delgado family, located in the Moon street # 94. The mansion was built in the late nineteenth century (Palacete de la familia Gelpí-Delgado, ubicada en la calle Luna # 94. La mansión fue construída a finales del Siglo XIX).

OLD WOODEN HOUSE

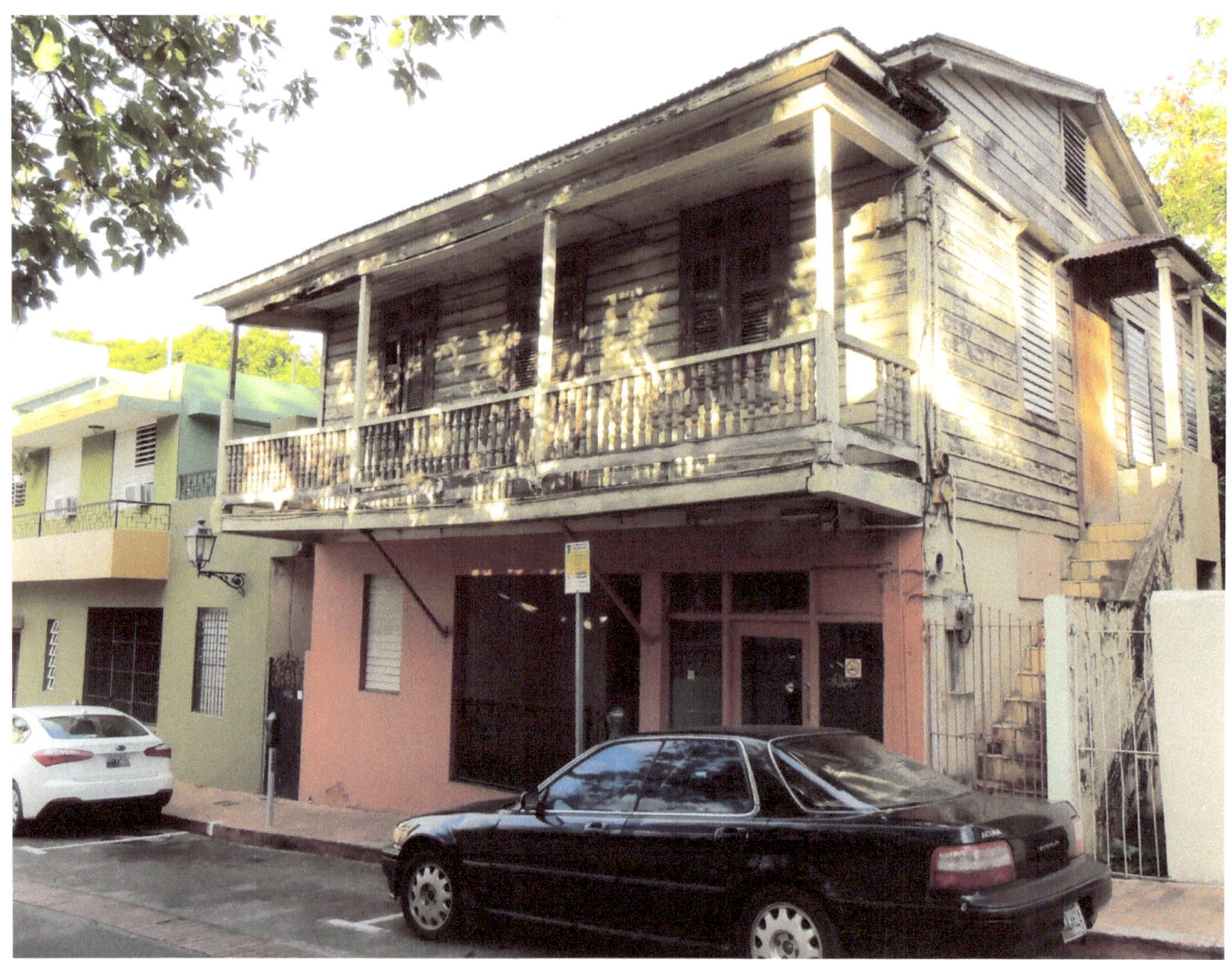

Old wooden house with balcony in San Germán (Vieja casa de madera con balcón en San Germán)

SUN THEATER

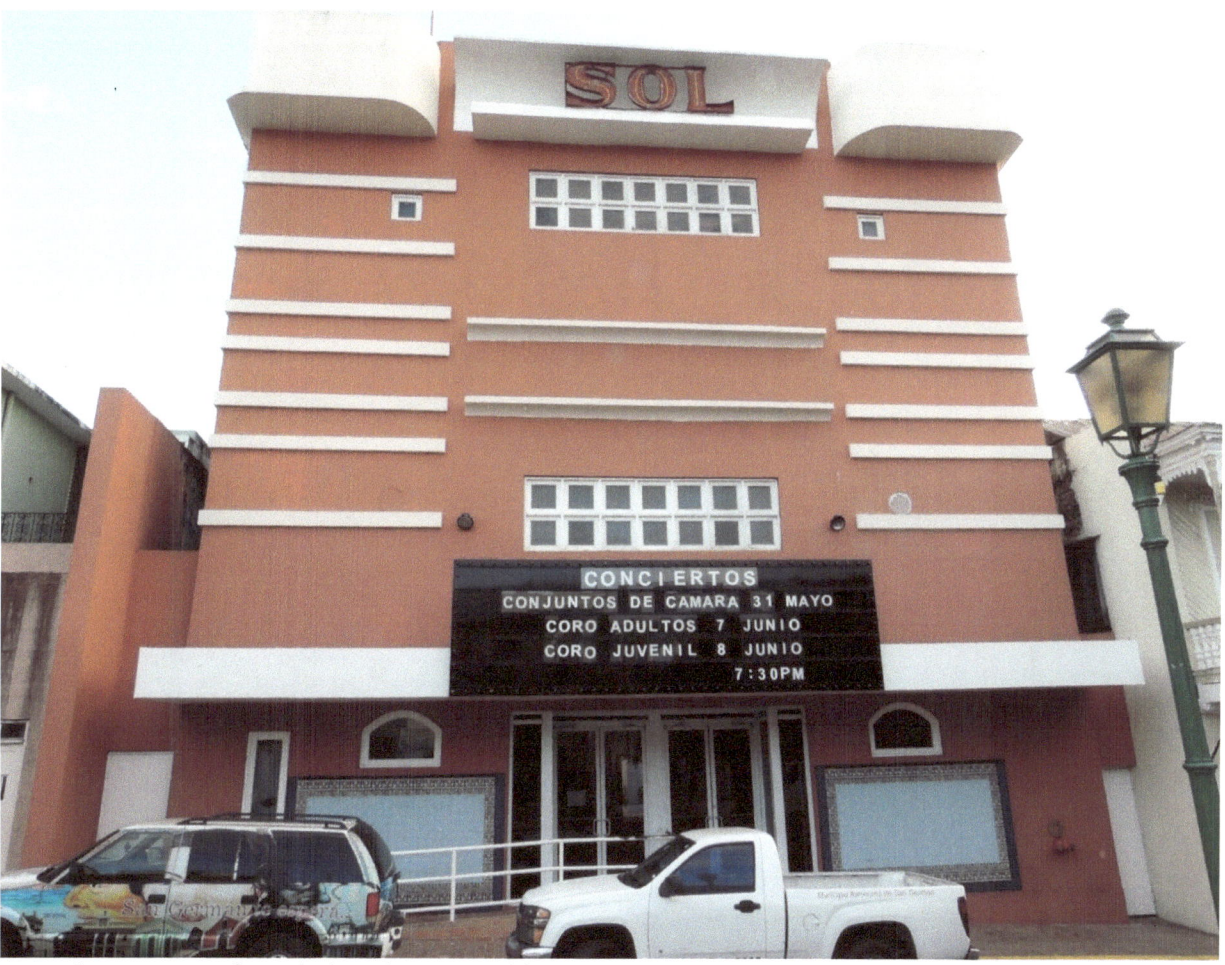

Sun theater, was founded and managed between 1915 and 1920 by Don Jorge Quinones. Acquired by Max Quiñones after being destroyed by the hurricane San Felipe in 1928, which rebuilt it and turned into cinema (Teatro Sol, fue fundado y administrado entre 1915 y 1920 por Don Jorge Quiñones. Adquirido por Máximo quiñones luego de ser destruido por el huracán San Felipe de 1928, que lo reconstruyó y convirtió en cine)

PORTA COELI CHAPEL

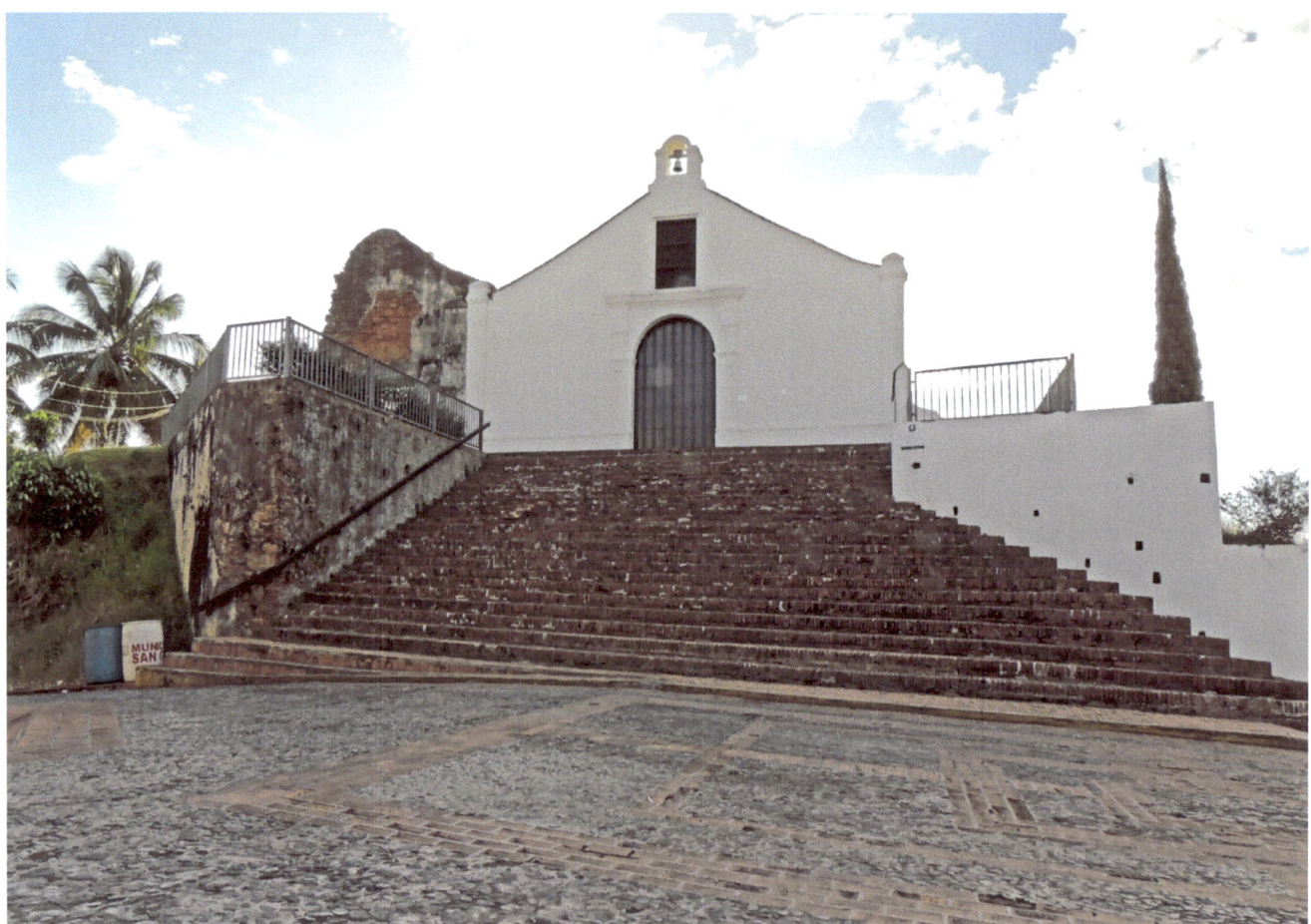

Porta Coeli chapel is the oldest religious temple of Puerto Rico outside their capital. It was built between 1606 and 1607 as a chapel of the Convent of Santo Domingo [now demolished]. Sefe today is a museum of religious colonial art (Capilla de Porta Coeli es el templo religioso más antiguo de Puerto Rico fuera de su capital. Fue construida entre 1606 y 1607 como capilla del Convento de Santo Domingo [ya demolido]. Hoy es sede de un museo de arte colonial religioso)

WOODEN CROSS

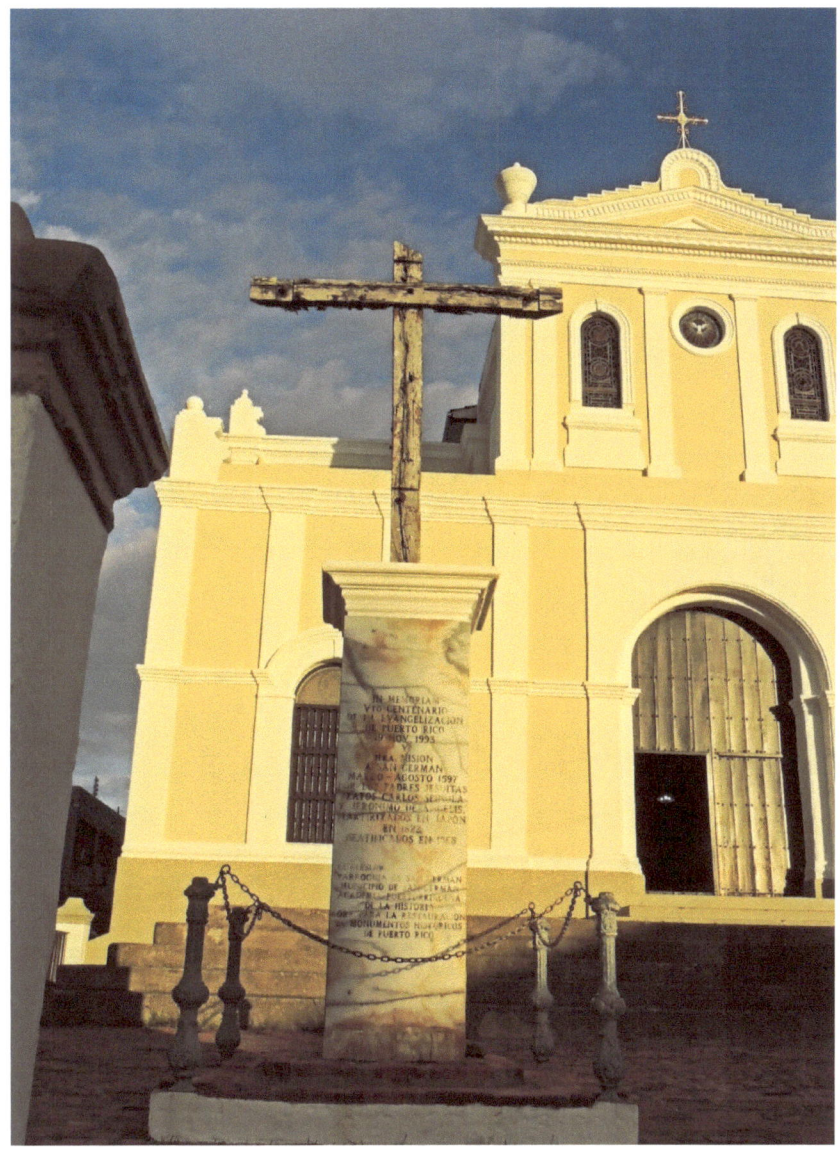

Wooden cross commemorating the fifth centenary of the evangelization of Puerto Rico, located front of the church St. Germanus of Auxerre (Cruz de Madera que conmemora el quinto centenario de la evangelización de Puerto Rico, ubicada al frente de la iglesia San Germán de Auxerre)

SANTO DOMINGO PARK

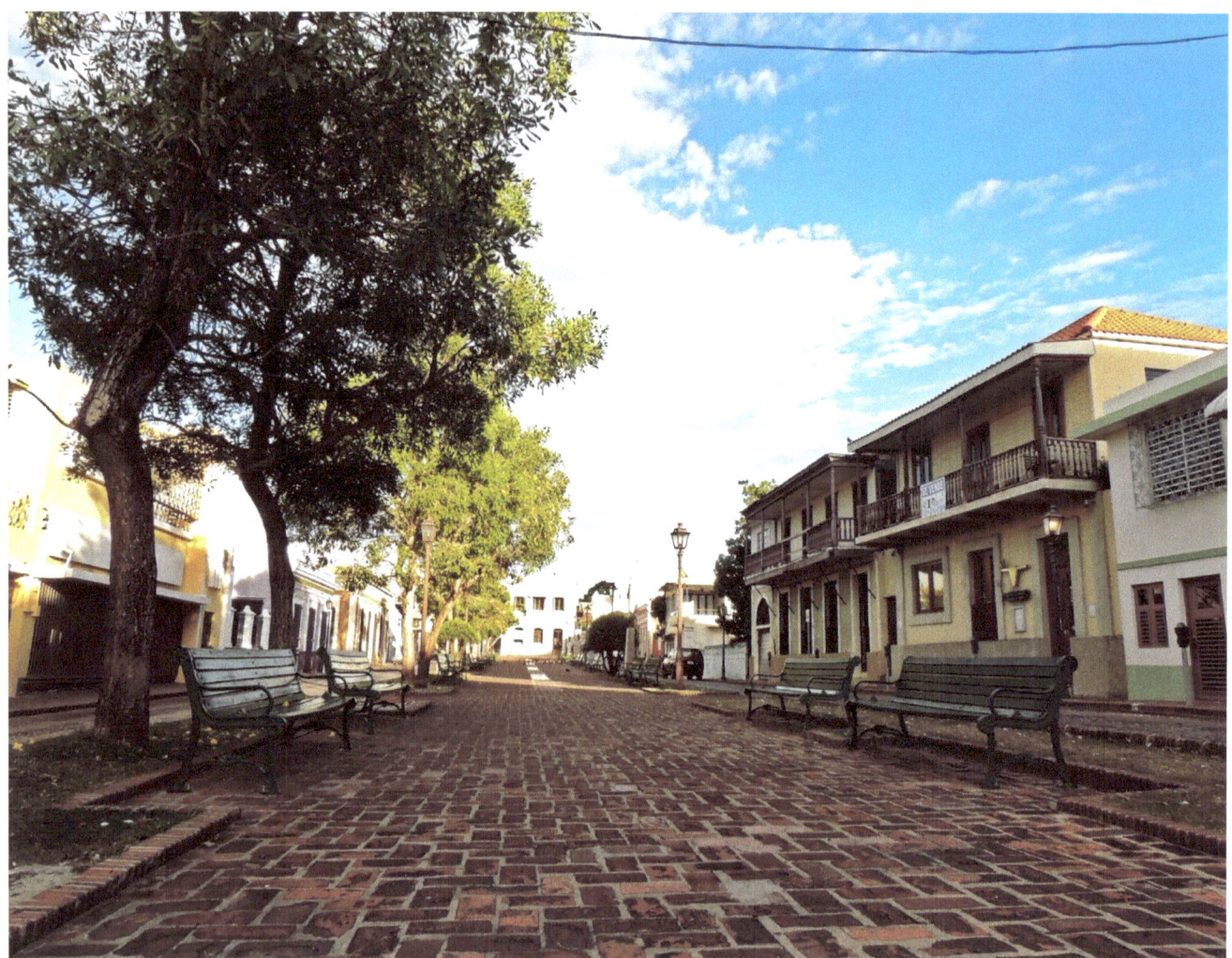

Square or Park of Santo Domingo. Square which today houses busts of illustrious personages of San Germán (Plazuela o parque de Santo Domingo. Plaza que hoy día alberga bustos de personajes ilustres de San Germán)

LAS LOMAS RESTAURANT

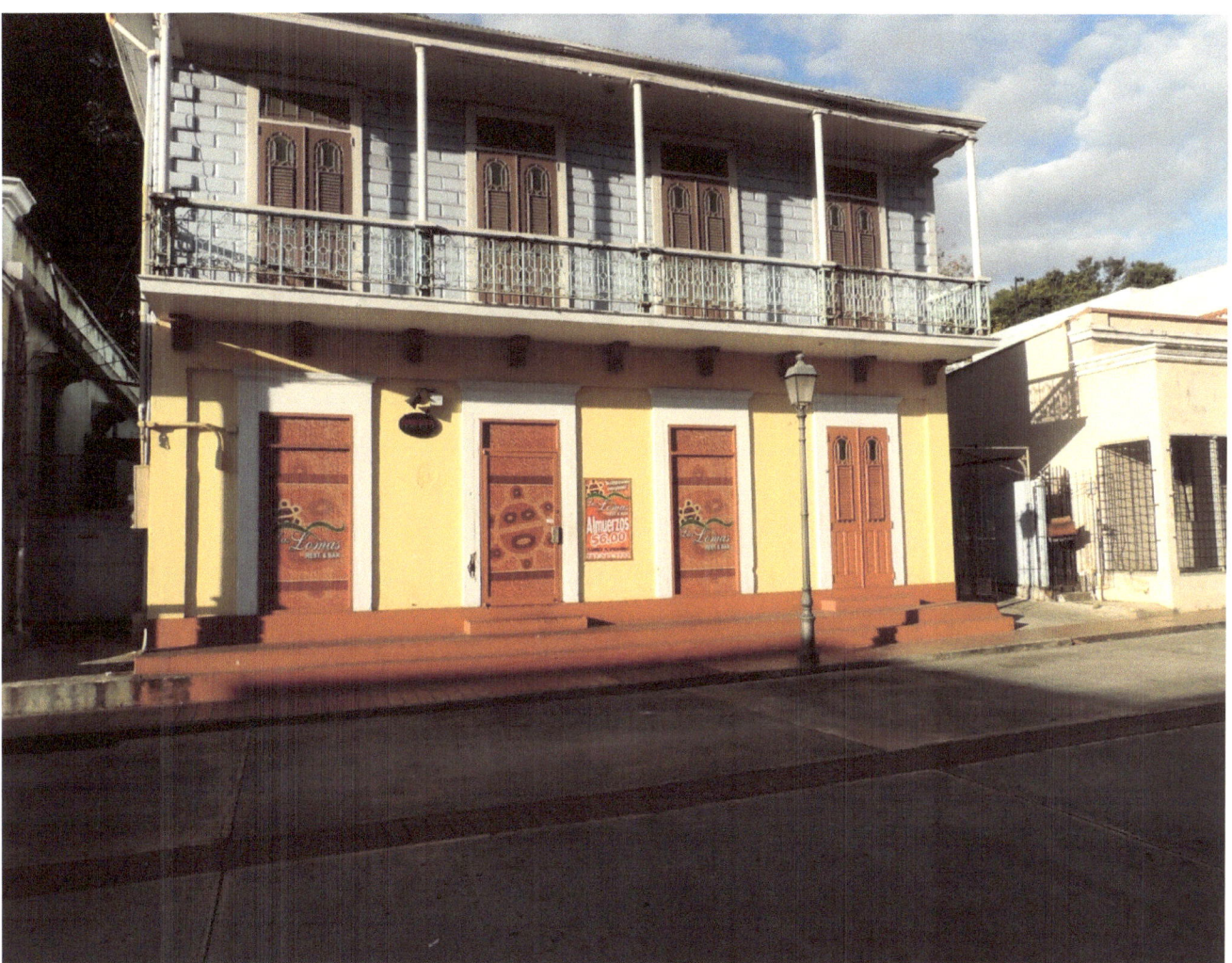

Las Lomas Restaurant at Luna Street (Las Lomas Restaurante en la calle Luna)

ALBERTO R. ESTRADA

DAWN IN MOON STREET

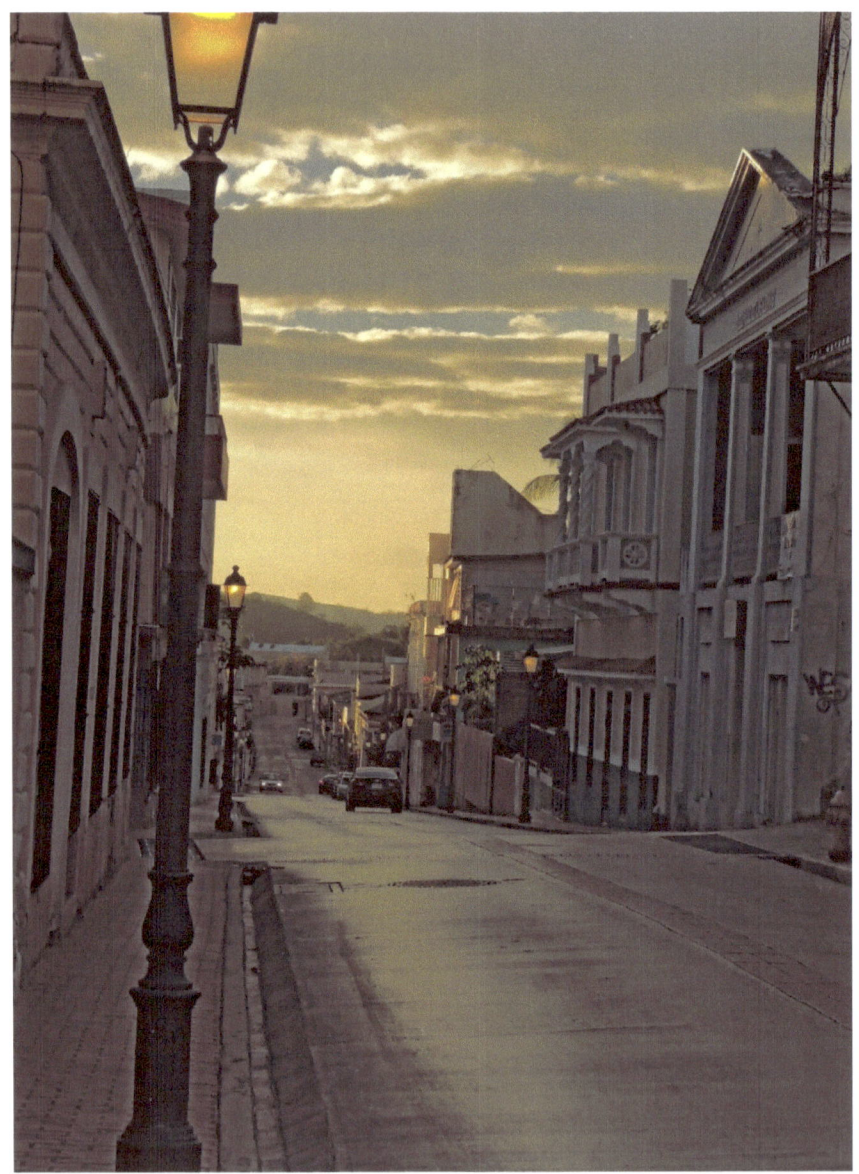

Moon street, at the dawn of San Germán (Calle Luna, en el amanecer de San Germán)

SANTO DOMINGO PARK

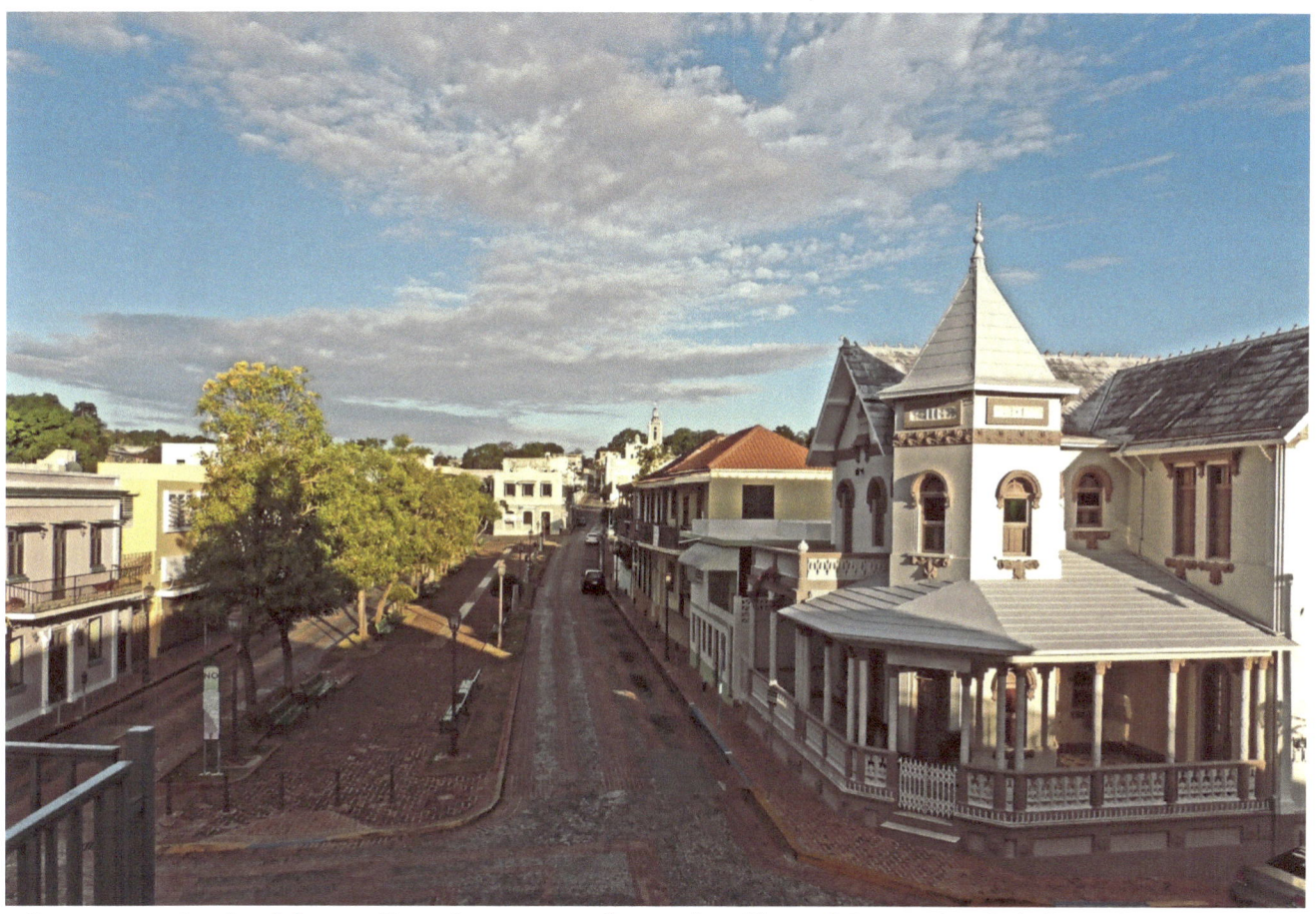

Square or Park of Santo Domingo seen from the Chapel Porta Coeli (Plazuela o Parque de Santo Domingo visto desde la Capilla Porta Coeli)

BELL TOWER

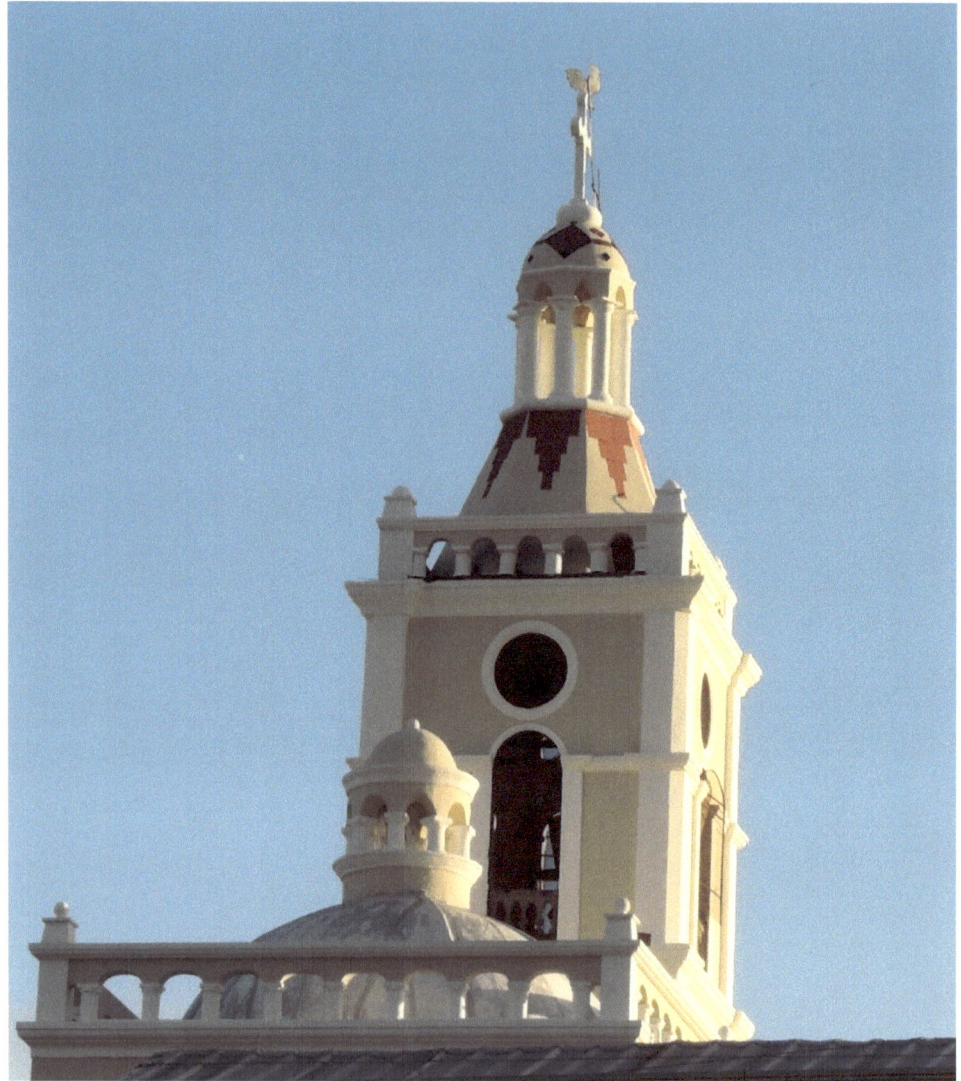

Belfry of the church of St. Germanus of Auxerre (Torre del Campanario de la Iglesia San Germán de Auxerre)

COSS OF THE MOON

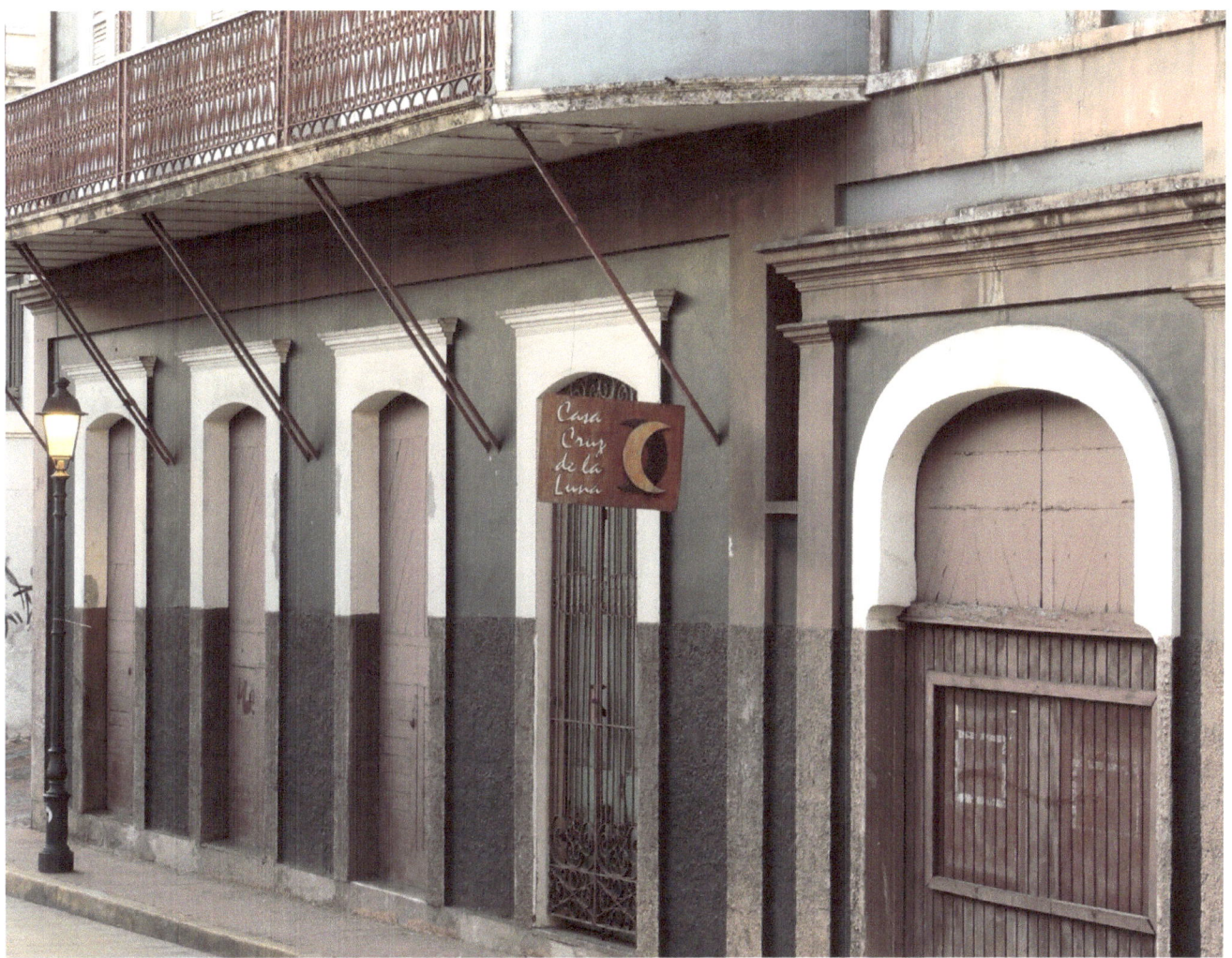

Cross House of Moon in San Germán (Casa Cruz de la Luna en San Germán)

ORCHIDS ON THE CORNICE

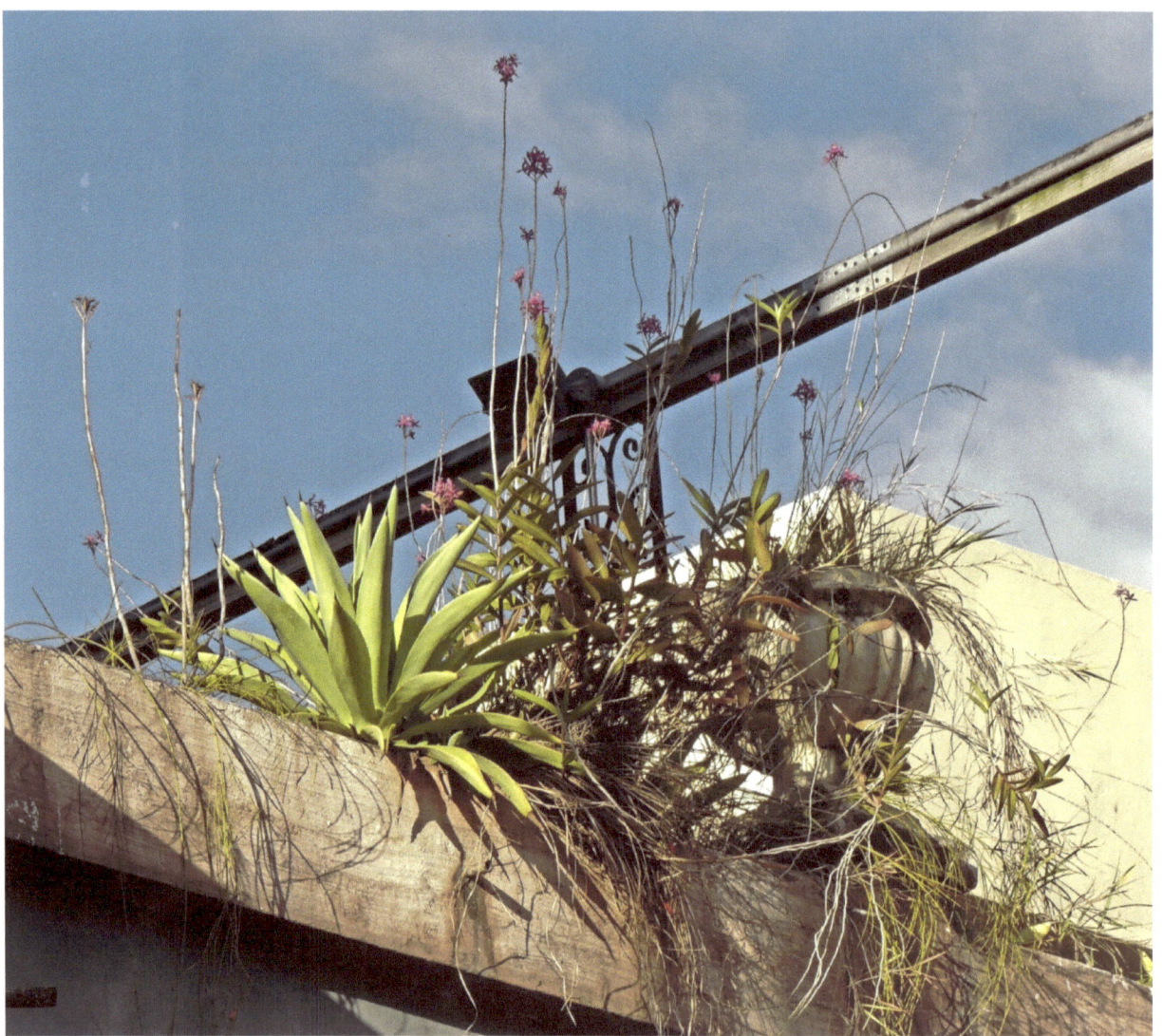

Orchids on the ledge in a narrow street in San Germán (Orchids sobre la cornisa en un callejuela de San Germán)

A RUIZ-BELVIS STREET CORNER

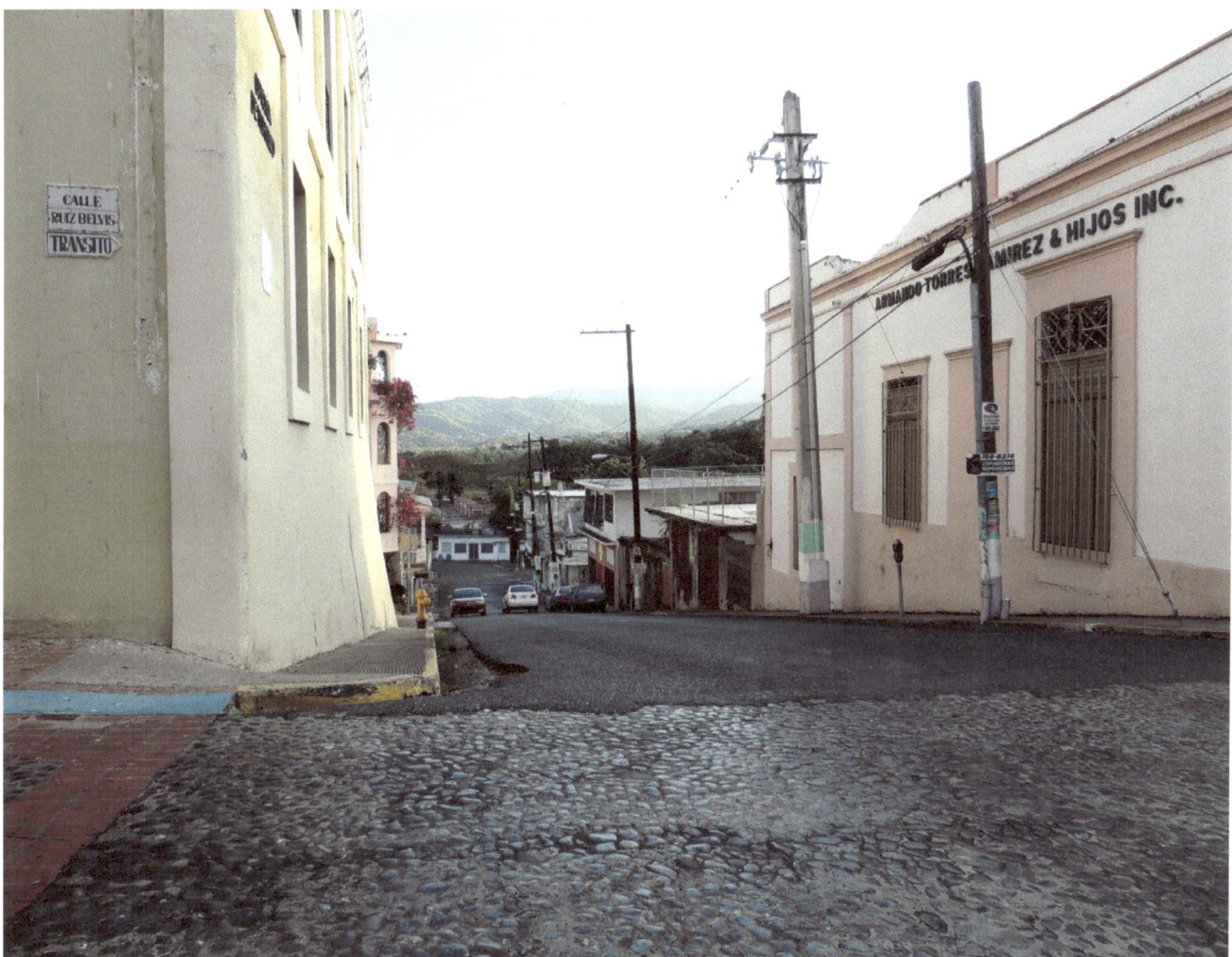

Confluence of Ruiz Belvis and Carro streets in San Germán (Confluencia de las calles Riz-Belvis y Crarro en San Germán)

BRICK STEPS TO THE CHAPEL

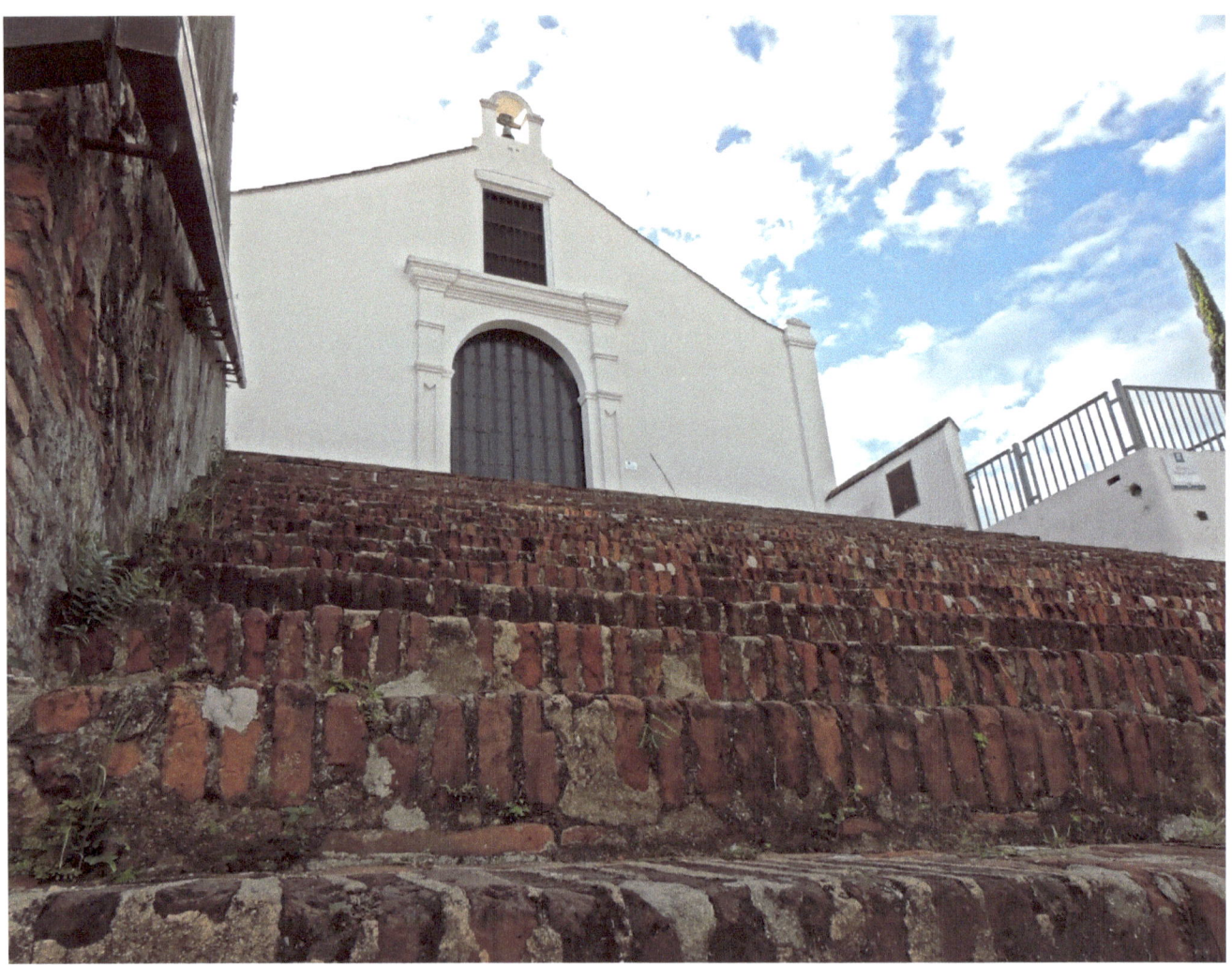

Brick steps leading to the Chapel Coeli (Escalones de ladrillos que conducen a la Capilla Coeli)

RAMA STREET

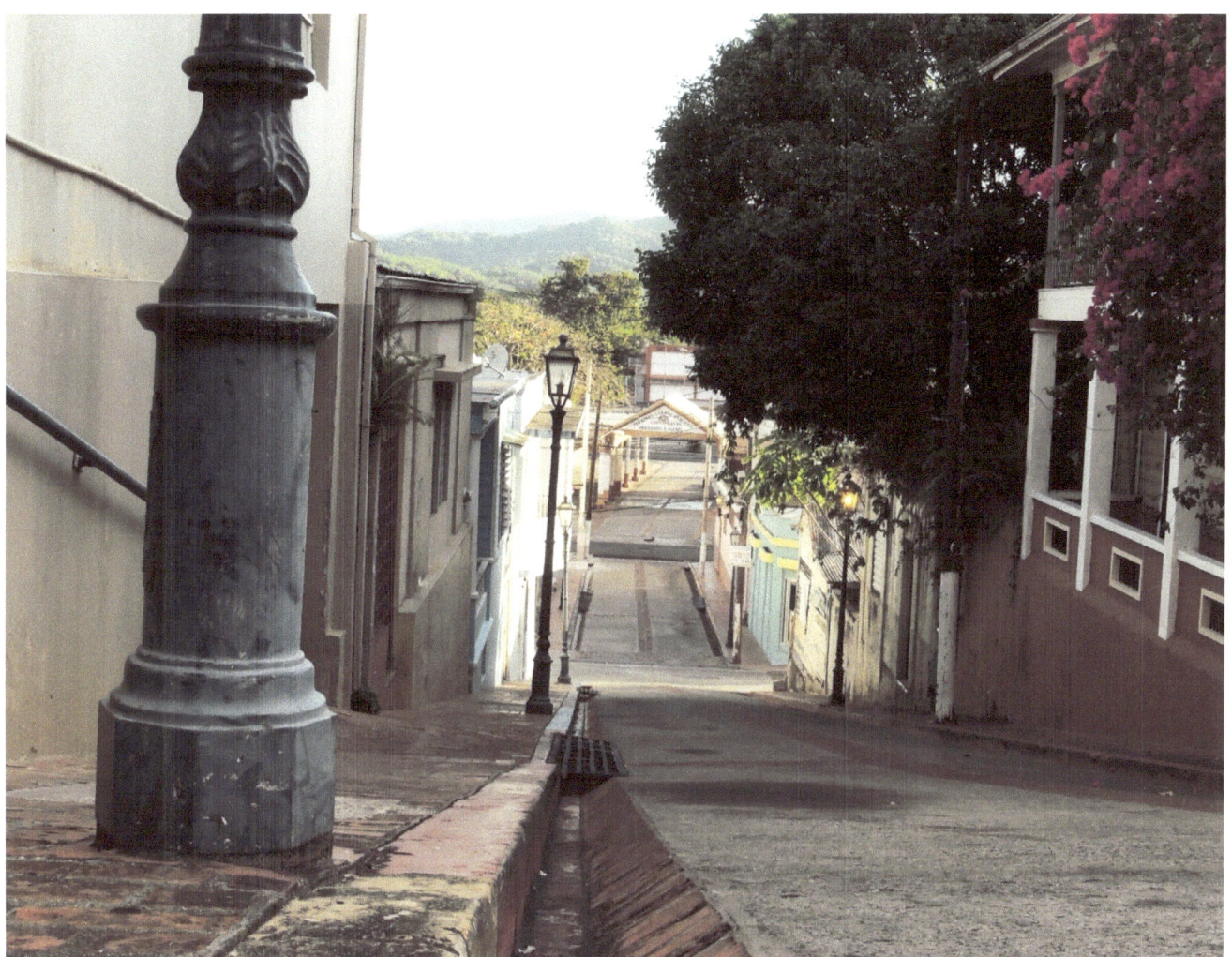

Rama street down, from the corner of Ruiz-Belvis street (Calle Rama abajo, desde la esquina con la calle Ruiz-Belviz)

PIGEON ON BRICKLAYING WALK

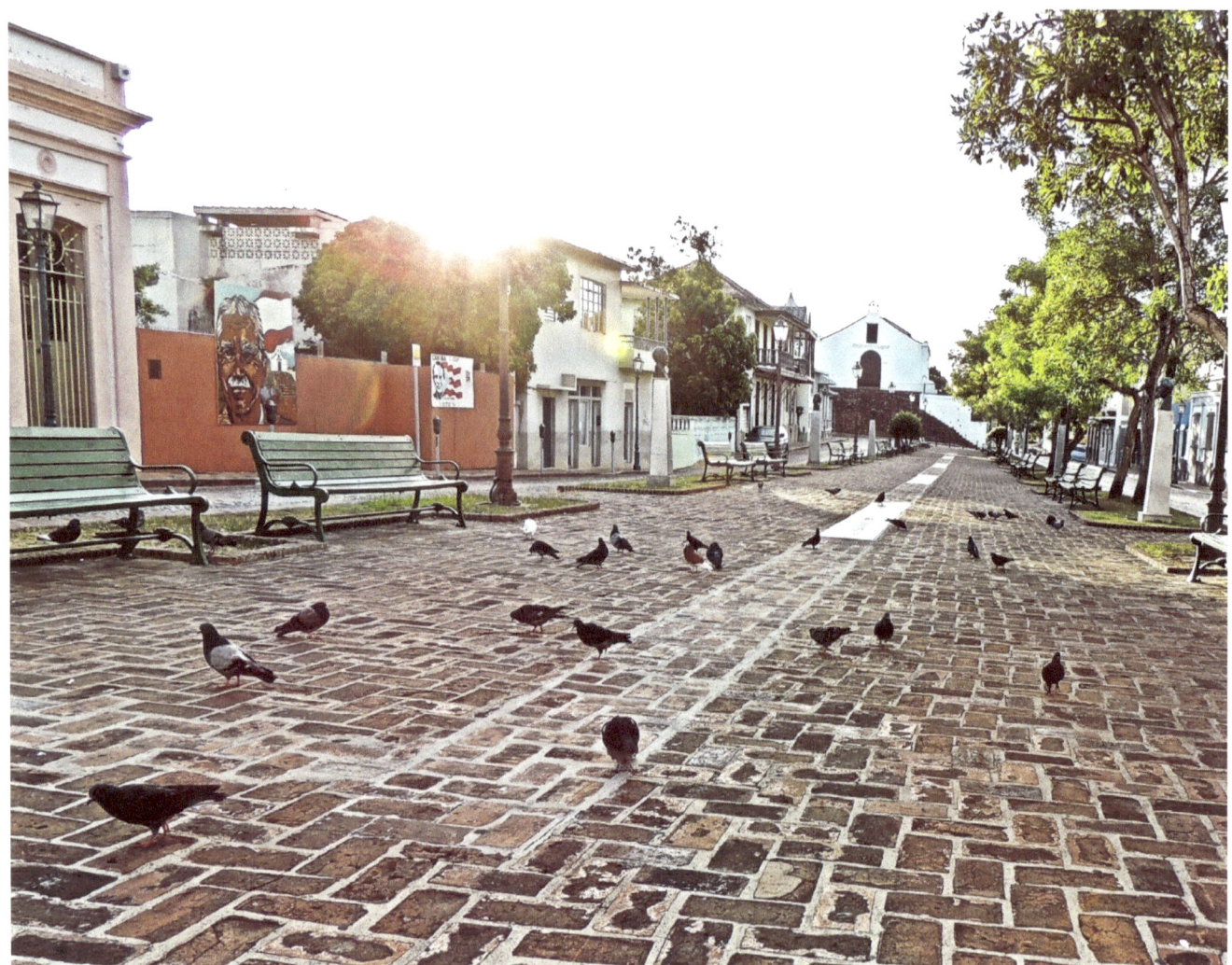

Pigeon on a bricklaying walk Santo Domingo Park (Palomas sobre el paseo enladrillado del Parque Santo Domingo)

ABOUT THE AUTHOR

Alberto R. Estrada-Acosta (born in Havana Cuba in 1953), is a biologist with experience in zoology, ecology, and management of vertebrates. He has a degree in Biological Sciences at the University of Havana (1981). He has conducted research in her area of herpetology (the study of amphibians and reptiles), ornithology (study of birds) and bioacoustics of amphibians.

Alberto has published more than fifty articles in scientific journals (peer review) of Cuba, Colombia, Spain and the United States on their findings and research on terrestrial vertebrate fauna of his native Cuba. He is also the author of several books.

He was founder and president of *eleuth* Productions Inc., a family owned company of digital productions (video and photography) between 2006 and 2015. He is now retired, but continues to write and publish books and taking pictures.

All photographs that appear in the book were taken by the author.